Kubrick's
2001: A Space Odyssey

How Patterns, Archetypes, and Style
Inform a Narrative

Albert Halstead

Leonine Productions,ᔆᴹ LLC

Cover design by Mike Boas

Illustrations 1 through 12, copyright 1968,
Turner Entertainment, a Time Warner Company

ISBN 978-0-615-34322-8

This book is printed on acid-free paper.
Printed in the United States of America.

Published by Leonine Productions, LLC
7 Spring Street
Waverly, NY 14892

Book production by Emprise Publishing, Inc.
1104 Murray Hill Road, Vestal NY 13850-3836

for Ann Marie

Table of Contents

List of Illustrations

The illustration section is found between pages 50 and 51.

Preface

This book began as the text to a lecture first presented at the Albacon science fiction convention held in Albany, New York in October of 2006. Shortly afterwards I expanded the text and considered publishing it as an article in one of the film periodicals. Eventually, what began as an essay grew into something considerably longer and I realized that publishing my work as a monograph on Kubrick's *2001: A Space Odyssey* (1968) would be more suitable.

My approach has been to examine and interpret *2001: A Space Odyssey* as an independent work of art, not as a derivative or adaptation of any other work, including Arthur C. Clarke's short story, *The Sentinel*, and his novel, *2001: A Space Odyssey*, published a few months after the film's release. What follows is basically an analytical essay focusing on the film's complex formal system and style. I have not attempted to relate *2001* to any of Kubrick's other films or to other films within the science fiction genre. Nor have I discussed any connection to historical events at the time of its production or ideological trends popular during the sixties. Though such approaches are certainly worthwhile and may offer additional insight, they are beyond the scope of this essay.

The first part of the essay offers a brief overview of the events in each of the film's four main sections along with some interpretation of the most important symbols and associative elements. The essay then proceeds with an in-depth analysis beginning with the section titled "Further Analysis." From this point forward I discuss the film's formal structure, its style, and some of the various questions that have arisen regarding its themes and ideas.

2001: A Space Odyssey is not a difficult film to understand if you watch and listen to it carefully, and I recommend watching the film before reading this essay. If at all possible, view the film in a theater, preferably a 70mm print. If a print of *2001: A Space Odyssey* is not available, the next best option would be to watch the film on a Blu-ray or regular DVD on a high-definition television set. If one of the video formats is all that is available to you, try to view the film using the best quality television set and sound system you have available.

My hope is that this essay will be enlightening not only to those who admire *2001: A Space Odyssey*, but also to those who are merely curious about it, and even to those who don't admire it. It is one of the most important films ever made and there is much that both film viewers and film-makers can learn from it.

Any errors in the facts stated or any confusion that may result from a lack of clarity in either my arguments or my descriptions are solely the responsibility of the author.

A. Halstead

July, 2009

Acknowledgements

The author wishes to thank the following people for reviewing the text, offering suggestions, and providing support which helped to make this work possible: Grace Houghton, Vincent LoBrutto, Eric Swan, Ray Ortali, Ben Alpi, and Ann Marie Halstead.

Kubrick's 2001: A Space Odyssey

How Patterns, Archetypes, and Style Inform a Narrative

Sometimes the truth of a thing is not so much in the think of it, but in the feel of it.

— Stanley Kubrick, commenting on 2001

Introduction

When Stanley Kubrick's *2001: A Space Odyssey* opened in theaters in 1968, it was immediately controversial. Simultaneously loved and hated by audiences and film critics alike, the film was hailed as a masterpiece by some while others saw it as boring and abstruse. Still others dubbed it a "brilliant failure." It even put off many who considered themselves fans of the science fiction genre. Certainly, it was a film that was largely misunderstood and, I believe, this was so because it failed to meet what audiences expected of a science fiction film in the 1960's. The key to understanding *2001* lies in understanding how its form and style are used to convey not only a story, but also three large-scale ideas involving the evolution of the human race, the evolution of technology, and encounters with extraterrestrial life. To accomplish this, Kubrick had to expand the film beyond the conventions of the genre and narrative film in general.

In time, with the benefit of repeated viewings and greater time to reflect, viewers and critics began to see meaning and value in *2001*'s images that they had not seen before. They became aware of not only the level of innovation and tech-

nical expertise demonstrated, but also the film's success in embedding archetypal symbolism in a unique form and the genius required to execute this. Many have noted that after *2001*, science fiction films were never the same. Kubrick's odyssey raised the bar for production values in science fiction films and promoted the entire genre to a level of higher regard. More importantly, Kubrick transcended the genre by allowing style to play at least as important a role as story. Today, *2001* is regarded as one of the top ten greatest films ever made. This essay will, hopefully, show why as we investigate how patterns, archetypes, and style inform a narrative.

Opening Title

2001 begins with music. There is nothing but blackness on the screen, but we hear, or in most cases feel through the floor, a profoundly deep organ tone. As the first three notes of the fanfare are played we see the earth rising over the moon and the sun rising over the earth. These three celestial objects comprise a simple, powerful, majestic, and well-composed image. Centered in perfect alignment, these objects dominate the frame and immediately focus the viewers' attention. As the fanfare nears its end, the eye is drawn to the top of the alignment and the dazzling light of the sun. The alignment also forms the first grouping of three elements in the film, a significant pattern that will be repeated frequently. Equally important, the title demonstrates at the very outset Kubrick's command of music as a technique to amplify and harmonize with the moving image. What was needed here was a sound track that would command attention, accompany the visual ascent from darkness to light, and evoke a sense of triumph and awe. To this end Kubrick selected

Richard Strauss' *Also Sprach Zarathustra*, the tone poem inspired by Nietzsche's account of a man's philosophical and religious awakening. This is music that knows no fear. It addresses the universe boldly and embraces it; it addresses the audience and inspires it. Note that the ascending musical notes of the opening fanfare, C G C8va, are repeated three times, each repetition coinciding with the ascension of a celestial body. The odyssey begins with a triad in the image and a triad in the soundtrack. The film's title and, as we shall see, the triad of rising celestial bodies indicate that we are about to embark on a great journey not only into the vastness of space, but also through eons of time and the realm of philosophical, even religious, ideas. Indeed, this image coupled with the opening *Zarathustra* theme leaves no doubt that this will be a film that is primarily about very big ideas. With the title's combination of imagery and music, Kubrick has set a tone for his narrative that is at once mysterious, bold, fearless, and grand in scale. He has captured the essence of the entire film within its first ninety seconds. Our adventure has begun with one of the most stunning opening titles ever put on the screen.

Act I – The Dawn of Man

The first act opens with a shot of the light of dawn over a vast desert and the sound of wind blowing. This may be some region in prehistoric Africa, but it is certainly a desolate place. A family of apes eats with pig-like animals (tapirs). One ape is attacked and nearly killed by a leopard; later two families of apes fight over rights to a water hole. When night falls, the apes huddle under a rock ledge, watching and lis-

tening fearfully for the sounds of approaching predators. It seems they are rarely out of danger. The shots are composed in a way that allows the audience to observe their behavior from the viewpoint of an omniscient being who is far more advanced, much as extraterrestrial aliens would if they were somehow monitoring the progress of life on Earth, particularly the progress of this curious species of apes.

Although this sequence has no voice-over narration or title cards, the images presented tell us a great deal. At this point in their evolution, the apes have not learned to use tools of any kind nor have they acquired the skill of using fire. These opening scenes clearly indicate our ancestors lived in a very hostile environment in the midst of a vast space over which they had almost no control. Every living thing had to struggle in order to survive and the apes at this point seem to be barely eking out an existence. Thus, Kubrick has laid the foundation for a story that has taken the evolution of the human race as its main subject.

The apes awaken one morning to discover a large, black monolith that appears to have been deliberately placed near their den. Its origin is a mystery and its smooth, rectangular surfaces bear no inscription or markings of any kind. The appearance of the monolith is accompanied in the sound track by the "Kyrie" from Gyorgi Ligeti's *Requiem*. Owing to its precise right angles and form, we surmise that the monolith was fashioned by some form of intelligent being or group of beings with abilities far beyond that of the apes. A triad pattern is formed by the monolith, the sun, and the crescent of the moon in perfect alignment in the sky above. Following the appearance of the monolith, one of the apes discovers he can use a bone as a tool. Later and more significantly, the

apes discover that bones may also be used to kill other animals for food and as weapons to fend off or even kill other apes. Have these events been caused by the monolith or is its role more passive? The available evidence at this point allows no conclusion. However, one observation we can make is that an alignment of three things, whether three celestial objects or two celestial objects aligning with the monolith, is a pattern that has been repeated and, owing to its significance, one that we are likely to see again. Such alignments will, in fact, become a motif during the film. As the film continues, this pattern will become a subset of a more general pattern or super motif: the triad, which will reoccur in many forms with varying elements in both the images projected and the music in the soundtrack.

The importance of this pattern's meaning calls for elaboration. The triad is an archetype and an ancient symbol for the foundation or beginning of a process, including the idea of rebirth. In order to understand this, we need to understand that numbers, particularly the integers below ten, each have a unique quality in addition to their significance in representing a unique quantity.[1] Imagine a space with nothing in it. Beginning with the first element, we have the quality of oneness or unity. The second element is divided from the first and stands in opposition to it, but together they create an extension – the first dimension. Adding a third element creates the triad which establishes a second dimension or surface which becomes a threshold to the universe or the foundation of all that will be built. So, if we were to reflect the quality of these numbers as opposed to the quantities which they represent, we would count one – unity, two – division or polarity, three – through and out into the universe.

As an archetype, the triad is found in many different cultures and societies throughout the history of the human race. Below are some relevant quotes which may offer additional insight.

> The One engenders the Two, the Two engenders the Three, and Three engenders all things. *The Tao Te Ch'ing*

> The triad is the form of the completion of all things. *Nichomachus of Gerasa*

> Three is the formulation of all creation. *Honoré de Balzac*[2]

Triads that occur in *2001*, particularly those involving the monolith and celestial objects, are used repeatedly to evoke the idea of thresholds to new experiences, thresholds or doorways that opened to the human race at critical times during its evolution. The repetition of such patterns underscores their importance to the narrative, particularly the important steps in the evolutionary process the film presents. On several occasions during the film, rare alignments of the sun, planets, and satellites signify critical points in time, and times that will have a unique quality. The idea that cycles or periods of time have a quality or meaning brings this repeated pattern into correspondence with ancient astrological ideas which are also rich in archetypal symbolism and common to many cultures throughout history up to the present day.

As Act I ends, the inventive ape who successfully used his bone-tool as a war club celebrates his victory by tossing the bone high into the air. We have witnessed the beginning of the end of our human ancestors being dominated by their environment. They now face their world empowered by a new confidence.

Act II – A Celebration with a Shadow of Complacency[3]

A striking cut presents us with a graphic match from the bone-tool falling through the sky to a man-made satellite orbiting Earth. In the blink of an eye, millions of years have passed and tools made from bones have been succeeded by satellites loaded with sophisticated precision instrumentation constantly circling the globe. A new triad is formed by the satellite, the earth, and the sun. We hear Johann Strauss' "The Blue Danube" waltz begin to play in the soundtrack, a piece written in three-quarter time that evokes gliding, rotational movement. Next, a magnificent, rotating space station appears followed by a shot of the Pan Am shuttle Orion gliding towards it. The graceful movement of these objects moving through space to "The Blue Danube" welcomes us to the first year of the twenty-first century. The celebration begun by the creative ape-man of prehistoric times continues: the human race has moved beyond Earth into space and our tools have evolved with us to the point where they may now operate without us, and millions of miles beyond our direct physical control.

A stewardess in zero gravity cautiously treads her way through the Orion's interior to attend to a passenger. Inside the shuttle's cockpit, we see the pilot and copilot at the control console. This shot provides an excellent example of Kubrick's use of cinematography and mise-en-scène working together as stylistic techniques to convey what is most important about the scene.[4] The angle of the shot is over the shoulders of the pilots. Consequently, we see them seeing what we are seeing – the Orion's control console with its graphic displays, telemetry, and computer-assisted navigation. This is the

subject of the shot, not the pilots. As the subsequent tighter shot confirms, this is what Kubrick wants us to see – machines that have advanced to the point where they are able to detect and communicate important information: a significant point in the evolution of the tools that humans depend on and, as we shall see, a prelude to artificial intelligence.

Inside the passenger compartment, we find our second protagonist and modern-day successor to the tool-inventing ape, Dr. Heywood Floyd. Traveling as the only passenger, we see that this incredible journey (especially for audiences in 1968) and the technology which surrounds him have become so familiar and mundane that he has fallen asleep during the flight. Contrast this to the curiosity, amazement, and jubilation of the ape when he discovered that a bone could be used as a tool.

The Orion synchronizes its rotation with the space station to prepare for docking and the two machines dance in synchronous harmony. We continue on a journey through space and time witnessing all that the human race has accomplished: a grand, elegant clockwork where humans appear insignificant compared to their machines and have been nearly assimilated by them. On arriving at the space station, Dr. Floyd engages in banal conversation with the station's staff and telephones home to wish his daughter a happy birthday. All seems uneventful and routine until he meets a group of Russian scientists who have just come from the moon and are returning to earth. The conversation starts out friendly and relaxed, but becomes increasingly tense as the Russians question Floyd about odd things that have been happening at an American moon base near Clavius. When one of the scientists presses Floyd for more specific informa-

tion, Floyd tells him he is not at liberty to discuss it. The audience is now confronted with a second mystery, the first being the source and function of the monolith that the apes encountered earlier.

Floyd's voyage continues aboard a second transport, the Aries, which carries him to the U.S. moon base. Like the Orion, the Aries approaches its destination maintaining a graceful pace with the music. Again, we have a shot of the pilots at the control console completely absorbed in the constant stream of information it is feeding them along with its shifting patterns of color. This kind of shot is another motif that will be repeated many times in the film. As the Aries lands, Kubrick allows sufficient time for us to take in the extraordinary detail of the architecture and complex operation of the landing facility as well as the spacecraft. We wonder at a technology so advanced and grand in scale that it would have appeared magical to humans a century before, not to mention the ape-men. The magnificent harmony with which the machines of the twenty-first century function, reinforced by the music in the soundtrack, constantly conveys the idea that this is a time of celebration for technology and confidence for the human race. However, it is equally interesting to note that the importance of the humans at this point during their odyssey appears to be waning. Their behavior and dialogue are neither interesting nor dramatic. We have learned more about the operation of the machines they live with than we have learned about them as individuals. We also observe that the interiors of these twenty-first century machines, though very clean and well ordered, tend to be rather stark and empty, lacking a lived-in look. The humans seem awkward and rather out of place in such surroundings. Needing food and toilets, they are almost a form of pollution

living inside the machines. You get the impression that if these machines could think, they would consider themselves superior to the human race.

After arriving at the lunar base, Floyd gives a presentation to the administrators and his fellow scientists revealing the nature of his mission. We learn that the great secret the Americans have been guarding has nothing to do with any sort of epidemic, but rather the discovery of an object that appears to have been made and deliberately left on the moon by an alien intelligence. Floyd reassures his colleagues that everything is under control, but insists that tight security and secrecy must continue. Notably, Floyd's speech, for all its scientific and world-security import, appears overconfident and remarkably devoid of excitement or any sense of urgency. When Floyd asks if there are any questions, he receives only one from a colleague concerned about how long the phony cover story will remain in effect. The rest of his audience remains mute. As strange as it may seem, this peculiar character behavior represents that of most of the characters we have seen thus far and it indicates that Floyd's role is part of a larger scheme where events unfolding on a broader scale matter more than characters as individuals.

Floyd and several scientists from the base take a lunar transport to the site where the mysterious object was discovered. During the flight, they eat synthetic sandwiches, congratulate each other, and discuss the powerful magnetic field that the newly discovered object is emitting. They also mention that it has been determined that the object was buried beneath the lunar surface some four million years ago. As the transport passes over the moon's surface, we hear strains of Ligeti's ethereal choral piece, *Lux Aeterna*, and witness

starkly beautiful lunar landscapes. Another triad formed by the transport, the earth, and moon heralds the coming of another important moment for the human race which is not only on the threshold of exploring space beyond the moon, but also about to deal with the first evidence of extraterrestrial life. The tone set by the unearthly, Gothic-like lunar landscape resonating with Ligeti's music imparts a mysterious, religious quality to the scene.

When Floyd arrives at the excavation site, we see that workers have unearthed a second monolith which looks identical to the one discovered by the apes. The volume of the *Requiem* chorus in the sound track rises as Floyd and his group approach the monolith. Floyd reaches out and touches it and, for a moment, we wonder if he has any sense of how far he is reaching back into his prehistoric past, making contact with this extraterrestrial artifact just as his simian ancestors did. However, such ideas are quickly dispelled as the group gathers for a photograph demonstrating more interest in making a record of themselves at a historic discovery than the discovery itself. Suddenly, we hear a piercing, high-pitched sound as a second extraordinary alignment occurs formed by the monolith, the rising sun, and Earth. Our protagonists are again standing before a threshold about to take another giant step in their journey. Yet, what is most peculiar and prominent in the scenes leading to the end of Act II – Floyd's speech at the moon base, the conversation in the moonbus, and the group's behavior at the excavation site – is that in spite of this astounding discovery, the mystery of its origin, and the import of the rare celestial alignment occurring simultaneously with the radio signal, Heywood Floyd and his contemporaries have exhibited remarkably little curiosity and even less awe or wonder that one would expect

to see in response to these extraordinary events. What we witness instead is a disturbing amount of vanity, self-assuredness, and complacency. As we leave the second act, Kubrick has given us a sense that the human race is approaching an event that may forever alter its consciousness and that that alteration is something for which the humans in this chapter of their history are totally unprepared.

Act III, Part I — Have Humans Gone Too Far?

The odyssey continues with a shot of the interplanetary transport Discovery moving slowly through the blackness of space en route to Jupiter. Eighteen months have passed and humans have now ventured farther out into the solar system than ever before. We are introduced to two new characters, Frank Poole and David Bowman. As they exercise and calmly go about their daily routines, the music in the sound track evokes an atmosphere that is very different from the celebration that opened Act II. Initially, the general mood here is one of reservation. Even the ship's name reflects a less aggressive stance compared with the names of its predecessors, the Orion and the Aries. The somber, subtle tones of the "Adagio" from Aram Khachaturian's *Gayane Suite* gradually evoke feelings of sadness and foreshadow something troubling, even ominous, may take place on board the Discovery.

The third important character we meet is the HAL 9000 computer. Nicknamed Hal, the computer possesses an extraordinary degree of artificial intelligence and actually runs the entire ship, leaving Frank and Dave with little more to do than monitor the Discovery's progress. Hal is sentient, man's ultimate machine, and is trusted to take care of every-

thing on board including preserving the lives of the three crew members who are in a state of hibernation. Hal is extremely polite and considerate towards Frank and Dave. His attention to their every need is almost motherly. He responds with more emotion than Frank after Frank's parents celebrate his birthday in a video transmission. Hal even expresses emotions to the point where he appears to be overly sensitive and more emotional – if not more human – than his human crewmates. With Hal, we see that machines have now evolved to the point where their technical perfection combined with their ability to respond emotionally has seduced us into trusting them to perform a major role in a critical mission that includes piloting the ship and monitoring life support for all five astronauts on board. With the advent of Hal, another milestone has been passed: both intellectually and emotionally, our human protagonists now stand very much in the shadow of their machines. This situation is affectingly brought to the fore in the scene where Frank watches the video from his parents, and again, in the scene where Hal defeats Frank in a game of chess. Frank is humiliated though Hal covers for him by being very gracious. Throughout these two scenes, Kubrick uses Khachaturian's "Adagio" to evoke a funeral-like atmosphere reminding us of the eclipse of humanity that is taking place while Frank and Dave show no awareness of it.

As we approach the end of the first part of Act III, Hal lures Dave into a conversation by expressing an interest in Dave's sketches. Hal then moves on to the matter he is really concerned about by asking Dave if he has had any second thoughts about the mission. Hal probes Dave to see what Dave might know about strange rumors and stories going around before the start of the mission. Dave listens carefully,

but either doesn't know or can't say what he knows about these stories. Hal apologizes for being "silly" in asking such questions. Dave maintains a poker face, but in his eyes we can sense that he is wondering as are we, why such a peculiar line of questions? What is Hal really trying to find out and why is he so concerned about the mission? Dave has witnessed the first sign of a crack in Hal's cybernetic personality and now it is Hal who feels embarrassed as he has tipped his hand in his unsuccessful attempt to manipulate Dave.

Could the red color of Hal's all-seeing electronic eye betray a malevolence that has yet to surface? Has artificial intelligence advanced to the point where machines are ready to act on their assumption that they are superior to human beings?

Act III, Part 2 — Our Tools Betray Us

As Hal is about to conclude his conversation with Dave Bowman, he suddenly detects a fault in the ship's antenna circuit and insists that the unit will fail in seventy-two hours. Dave retrieves the unit and tests it, but can't find anything wrong with it. Hal's twin HAL 9000 on Earth analyzes the unit, but disagrees with Hal's forecast. Hal insists the discrepancy is due to human error, but Frank suspects that it is Hal who is malfunctioning and recommends privately to Dave that Hal be shut down.

Hal discovers the plan to disconnect him and kills Frank and the three hibernating crew members. At this point, the evolution of man's tools takes yet another major turning point. We now have our first case of machine turning against

man, in this case plotting and deliberately killing four people. Hal then attempts to kill Dave by stranding him outside the Discovery, but Dave outwits Hal and manages to reenter the ship. Once inside, Dave ignores Hal's promises and pleas, and begins to disconnect Hal's vital circuits to shut him down. Now, man must kill his tool in order to survive. Hal dies singing the lyrics to "Daisy Bell," a nineteenth-century love song, in one of the most ironical scenes to ever appear in a science fiction film. Most importantly, humans have regained center stage in the drama.

Immediately after disconnecting Hal, Dave hears the voice of Heywood Floyd coming from a pre-recorded video message that had been stored on board before the Discovery's mission had begun. Floyd's message explains that the true purpose of the mission was made known only to Hal and that it is connected with the monolith discovered on the moon. Dave learns that the crew was to investigate the receiving end of a radio signal being sent towards Jupiter by the monolith and that this was the only thing the scientists were able to learn about the monolith.

Act IV – Jupiter and Beyond the Infinite

Dave leaves the Discovery and sets out in the remaining space pod, presumably to investigate where the signal is being sent. He discovers what appears to be a huge monolith floating in orbit around Jupiter. A triad is formed by the monolith, the sun, and Jupiter. The siren-voices of Ligeti's *Requiem* beckon us to a new threshold while a series of spectacular shots show Jupiter's moons coming into alignment with the sun. Having encountered alignments such as this

earlier in the odyssey, we know that this is likely to signify a critical time and that something extraordinary is about to happen. Dave approaches the monolith, but discovers that it is an illusion and what really lies before him is a portal to a great, black abyss. He crosses the threshold as the chorus in *Requiem* rises once again in the sound track and we share Dave's point of view as he embarks on a journey through space and time that the aliens now control. Dave is helpless and terrified, and we have lost the advantage of our omniscient point of view. We have no idea where he is going and are both dazzled and puzzled by the patterns of light and color through which he is flying.

Although this sequence has a narrative function – Dave's transportation to the alien world – its originality and artistic significance become more important when viewed as an abstract sequence within the film's plot.[5] Most important is the relationship between images, patterns of color, music, and the sensations these evoke. Kubrick has tried to give us an impression of what travel to a distant galaxy at superluminal speeds would feel like. Here, the space-time continuum has been warped or folded and we travel by means beyond spacecraft, or anything we understand about physics as we know it today. Kubrick correctly understood that whatever we would see or sense would be unlike anything we had ever experienced before. At times, Dave seems to be traveling back in time, perhaps to the dawn of creation itself, witnessing the birth of whole galaxies and star systems. Five diamonds appear ahead, then seven as Dave approaches primordial landscapes rephotographed using contrasting pairs of primary and complementary colors. These shots are intercut with extreme close-ups of his eye using the same solarization effect in the photography and similar complementary colors.

The light tunnel sequence ends abruptly with a cut from an extreme close-up of Dave's eye (returned to natural color) to his point of view looking out through the space pod's window. At first Dave is inside the pod, but then he is outside. To his amazement, the pod has landed in an elegantly furnished bedroom and although he is alone in this place, it appears the aliens have tried to construct a setting in which he will feel comfortable. The decor and furnishings are from an earlier century when one did not have to worry about machines that could think, deceive, or murder. Yet, in spite of their luxury and familiarity to any visitor from Earth, Dave's accommodations could also be viewed as a laboratory or cage in which he could be studied.

We hear voices, presumably the aliens', but we never see them.[6] From the time that he arrived, Dave has aged considerably. He walks about the room observing the adjacent bathroom, his reflection in the mirror, and his aged self eating at a table. He is as baffled by all of this as the apes would have been trying to understand their reflection in a mirror. Apparently, the Newtonian rules of cause-and-effect happening linearly in space-time do not always apply here. Dave tips over his glass of wine and it shatters as it strikes the floor. He stares down at the shattered glass then raises his gaze. In the next shot, he sees himself lying on the bed, near death. Both shots represent destruction, decay, and the inevitable increase in entropy that accompanies such processes.[7] The second law of thermodynamics[8] does operate in this part of the universe,[9] yet from a holistic point of view, Dave's death would signify a new beginning or even a renaissance. Making its final appearance in the film, the monolith stands at the foot of the bed. Dave raises his arm and points to it, then the shot is reversed and we see a transparent cap-

sule on the bed emitting an almost blinding light. Inside the capsule lies an infant: Dave has transcended his old body and become reborn.

The final scene: To the opening C G C$^{8va}$ notes of the *Zarathustra* fanfare, we come full circle back to Earth with the Star-Child in orbit. The final triad is formed as the frame descends from the moon to the earth and the Star-Child. Through this triad, Dave's odyssey is complete. Like the apes before him, he has survived a hostile environment in a vast space and evolved into a new form of being. He becomes the final element in yet another super triad created by the periods of time that have unfolded during the film with the earth corresponding to the past, the moon the present, and the Star-Child the future. Whatever the purpose of the Star-Child may be, Kubrick's odyssey of the human race ends on a hopeful note expressed in both the triad, the elements that comprise it, and the *Zarathustra* theme. The aliens have reached out to us with an unborn child. As the camera moves in, we see an expression that is mild and innocent. With eyes wide open with wonder, the Star-Child looks down upon the earth. Kubrick has given us a universal image of hope. The three notes of the fanfare together with all of the aforementioned elements of style have opened a new door for us and another journey is about to begin.

Further Analysis

Through the art of cinema, Kubrick has expressed three major ideas in *2001: A Space Odyssey*: 1) the evolution of man's tools, machines, and technology is an awesome thing to behold with consequences that may not be to our benefit; 2) the exploration of space and encounters with alien life are

mind-boggling experiences; and 3) the evolution of the human race and its destiny are awesome experiences to contemplate. These are ideas that are certainly great in both scale and scope, requiring a story spanning millions of years. Kubrick realized that presenting such ideas through a conventional narrative film would have overloaded the structure and required far too much screen time. His genius as a director lies in his solution to this problem. Rather than relying on forms of text (as in written or spoken language) or emotional character behavior, Kubrick took the bold step of relying on the power of imagery, particularly symbolic imagery and imagery driven by music to express his ideas. To this end, he integrated strategies from two forms of non-narrative film, specifically abstract and associational film form, into what is essentially a classical narrative film.

To understand the advantage of this multi-formal approach, we need to understand first how a film, any film, works. The shadows projected on a screen that make up what we call a film or movie are organized for some purpose. A film's formal system is what gives direction and purpose to the images moving on the screen.[10] Narrative form organizes images to tell a story which involves characters moving through a literary plot, i.e. a plan, involving a sequence of cause-and-effect-related events usually reaching some goal or logical conclusion. An abstract formal system organizes images primarily "through repetition and variation of such visual qualities as shape, color, rhythm, and direction of movement."[11] An associational film organizes images "to suggest similarities, contrasts, concepts, emotions, and expressive qualities."[12] Such films may suggest ideas and/or evoke emotions through their graphic, pictorial, or symbolic qualities, or through editing that allows us to see some similarity in

meaning or concept linking a set of images; however, they do not rely on characters or follow a literary plot.

Abstract form predominates in two sequences in *2001: A Space Odyssey*, the opening title shot and the light tunnel sequence, and it commingles with narrative form in the waltz sequence that opens Act II. However, it remains at work throughout the film, sometimes in a striking way as in those scenes where planetary alignments appear, or more often, in a subtle, pictorial way operating just beneath the plot's narrative surface as in the frequent close shots of control consoles or instrument panels, the scenes involving spacecraft in flight, and shots containing non-aligned triads. Kubrick used abstract form to stimulate our sense of sight and sound directly, relying on composition, visual aesthetics, choreography, and music to captivate our attention and to convey the emotional tone of a scene. In the opening title, for example, the general idea the formal qualities convey is a powerful awakening, rising, and moving towards the light.

Kubrick's associational strategies become apparent as we make the transition from the opening title to the first act where we see the correspondence between the rising sun and the light of dawn shot at the beginning of The Dawn of Man section. A second associational transition occurs between Act I and Act II with the famous cut from the bone tool to the satellite. The two images are juxtaposed so that we may contemplate the evolution of man's tools, the evolution of the human brain that conceived them, and the passage of millions of years of human history seeming like only a moment to a superior extraterrestrial race.

In retrospect, a number of shots in Act III now appear to offer far more meaning than we might have thought initially.

We have the long side shot of the Discovery looking like the sun-bleached skeleton of a dead fish drifting in a dead sea; then a human running in circles, going nowhere, passing three of his crewmates seemingly lifeless and already lying in their coffins. All happens under the watchful eye of the machine: silent, biding its time, and jealously guarding its secret. It is as if we are witnessing a scene in which someone is seriously ill and dying, but these moribund images integrated with the pathos of Khachaturian's "Adagio" represent more than the fate of Frank Poole and the three sleeping astronauts. They are a metaphor for a fading spirit that once had passion, curiosity, and verve that fueled a desire to explore, discover, and invent.

As Bowman approaches the alien world in Act IV, a row of five diamonds appears in the sky ahead, increasing to seven. Diamonds have long been associated with perfection, but the numbers five and seven have significant archetypal qualities. Five, from which the pentagram and the Golden Section are derived, has an ancient association with regeneration and life. Seven represents the steps to perfection, the unattainable, and self-transformation. Thus we have a strong connection between these elements and the fate about to befall Bowman in the alien suite.

The final sequence in the alien suite offers a garden of opportunities to form associations such as Bowman's observing himself in the mirror, then himself eating at a table. The first is a reflection in space, the second a reflection in time which, through a kind of out-of-body experience, affords Bowman a unique opportunity to observe objectively his accelerated aging and to contemplate the final step in his journey. This leads to Bowman's elegant last supper which suggests a ritual of preparation for his death and resurrec-

tion, and finally, Bowman's contemplation of the shattered glass of wine which represents the inevitable outcome of an irreversible process, not unlike his very temporal life, his deterioration, and his death. From the beginning of Act IV to the end of the film, Kubrick stimulates our imagination to really take flight. Through an act of cinematic poetry, he allows us to experience something beyond anything we have seen before. Thus we do not merely watch Bowman's bewildering and astounding experience; we share it with him.

Other prominent elements rich in associations include the monolith which suggests a doorway, threshold, or opportunity; and alignments which suggest creative time, major significant events at that time, evolution's relationship to time, the relationship between meaning and time, and synchronicity. Symbolism at a more general level occurs with the appearance of the various triads that suggest foundations, thresholds, regeneration, and the attainment of greater wholeness. The list of associations could be extended to finer details within the sets and staging such as the blackness of the monolith and outer space representing deep, inscrutable mystery, nothing and everything in one, the infinite. Much of the pleasure of watching an associational film derives from the freedom one has to make associations. The preceding examples are merely my interpretations. As with poetry, there are no right answers.

Through either their formal qualities or the concepts and emotions we may infer from their association, we derive meaning from the images, the importance of the meaning being proportionate to the recurrence of similar patterns (motifs). The film's motifs all have formal qualities which grab the viewer's attention and reinforce the idea of similarity, but it is primarily their associational qualities inter-

acting at key points with Kubrick's allegorical narrative that make the most meaningful impressions on our mind.

The film's narrative form also relies heavily on imagery as can be seen in similar patterns in the staging of characters' activities and events to show parallels between scenes in different sections. The scene where the apes discover the monolith, for example, and gather around it while the rising sun forms an alignment with the monolith and the moon is paralleled by the scene at the end of Act II when Heywood Floyd and his group gather around the monolith unearthed on the moon. Again, a similar alignment forms while the same music plays in the soundtrack. In general, story information conveyed by dialogue in *2001* is minimal, occurring in less than forty-one minutes of the film's 139-minute running time. Lengthy, less stimulating expository dialog along with voice-over narration, both often used in narrative films covering long spans of time, have been completely avoided. Titles appear occasionally, but these are quite brief and used only to establish the time or setting of some of the acts. As we have seen, Acts I, IV, and many of the sequences in Act II rely entirely on images to convey narrative information.

Music and lighting, along with patterns of color and motion, are used most often to convey the emotion of the various scenes while emotional speech, facial expressions, and gestures are generally minimized. Albeit unconventional, Kubrick's complex formal strategy yields a film with remarkable economy without sacrificing communication.

2001 was criticized for having a disjointed story plot, but its plot unfolds quite linearly in a structure that is not atypical of classical Hollywood cinema. The story plot is comprised of four major sections[13] which trace the journey of the

human race as it evolves in time and expands out into the solar system. Beginning with the Dawn of Man section set in a time roughly four million years ago, we see the human race take its first humble steps.[14] With a spectacular cut, we arrive at the year 2001 where we see humans and machines at the height of their glory. In the third act we move on to the Jupiter mission and the resolution of the inevitable conflict between man and artificial intelligence, and in the final act, we travel beyond time, concluding the odyssey with the birth of the Star-Child. Below is a more detailed breakdown which demonstrates some of the many parallels that occur among the various sequences:

▲ Prehistoric apes eke out an existence in a hostile environment that controls them.
▲ A mysterious monolith appears, origin and purpose unknown.
▲ The ape-men discover how to use primitive tools and begin to take control of their environment.
▲ We leap ahead four million years; man rules the earth and moon, yet his tools have also evolved and are on the verge of outshining him in their splendor.
▲ A second monolith is discovered on the moon and believed to be alien in origin, its purpose also unknown.
▲ Humans travel to Jupiter, purpose of mission not known at first. While their vitality continues to languish, a new kind of tool on board can think, respond emotionally, and is self-aware.
▲ Machine becomes paranoid and nearly succeeds in killing all of the human crew.
▲ Human, alone in a hostile environment, terminates machine, regains control, and continues with a new mission and a new awareness.

▲ Man is studied by the aliens and re-encounters the monolith. The time has come for him to die and be reborn with a new set of abilities and a new mission.

▲ The Star-Child returns to Earth and a new era is about to begin.

I have discussed how symbolic archetypes such as the triad have informed many scenes during *2001*, but it is quite evident that Kubrick also employed mythological archetypes such as the archetypal hero, particularly during the last two acts. In his book *The Hero with a Thousand Faces*, author and mythologist Joseph Campbell describes the common characteristics found in the Hero's Journey type of story or myth. Below is Campbell's outline of the Hero's Journey:

> The mythological hero, setting forth from his common day hut or castle, is lured, carried away or voluntarily proceeds, to the threshold of adventure. There he encounters a shadow presence that guards the passage. The hero may defeat or conciliate this power and go alive into the kingdom of the dark . . . Beyond the threshold, then, the hero journeys through a world of unfamiliar but strangely intimate forces some of which severely threaten him (tests), some of which give magical aid . . . The final work is that of the return. If the powers have blessed the hero he now sets forth under their protection (emissary); if not he flees and is pursued . . . At the return threshold the transcendental powers must remain behind; the hero re-emerges from the kingdom of dread (return, resurrection). The boon that he brings restores the world (elixir).[15]

Dave Bowman's adventure on board the Discovery and in the alien world closely parallels the journey of the mythological hero whom Campbell has described. Like Campbell's hero, Bowman also needs to pass through a number of thresholds to complete his journey or life mission. Hal's role may have been the "shadow presence that guards the passage." Certainly, Dave has been tested and magically aided by being reborn as the Star-Child. By the end of the film, we understand that his role is more Argonaut than astronaut, yet he really represents all of us as an "everyman" bearing witness to the close of the twentieth century while advancing to the next. His is the penultimate part in a drama that has presented the human race as the main character throughout the film. Several different characters have represented the human race in the course of the film's plot. Beginning with the ape-men who represented the human race when it was in its primitive infancy, we then leaped millions of years ahead where Heywood Floyd represented the humans at the end of the twentieth century. A year and a half later, machines have evolved to the point where they eclipse the new representatives of the human race, Dave Bowman and Frank Poole. Poole is slain, but Bowman survives to vanquish the machine and initiate the revival of the human race. The final form of the mythological protagonist is the Star-Child. Given the music in the soundtrack of the closing scene, integrated with the beauty and symbolism in the images, it follows that his mission will be to somehow alter the course of the human race for the better.

One might wonder why the role of the protagonist is shared by two characters in Act III. What is Poole's role? During the process of evolution, we know that some species

fail to survive. Frank Poole represents not so much a kind of human being, but a way of thinking and behaving that is destined to become extinct. In retrospect, his death is imminent. He is already dying as a person as we witness his detachment from his human roots. Moreover, Poole's thinking is too linear and lacks creativity. He struggles to keep abreast of the machine, but in the end it overwhelms him and drains the life out of him. Though Poole and Bowman resemble each other on the surface, Bowman's personality is the complementary opposite of Poole's in a number of significant ways. He is more thoughtful, open, and able to adapt. Bowman observes, listens carefully, and considers the consequences of his actions. He does not challenge Hal; he quietly engages in activities that Hal can't do. By the end of Act III, Bowman has emerged as the more forward thinking of the two and the one best equipped to become the "mythological hero."

Analysis of 2001's Style

If Kubrick's use of multiple formal strategies in one film was a stroke of genius, his way of integrating the stylistic techniques was equally original and brilliant. Kubrick elected to bring the power of all four techniques of film style to bear on the problem of communicating the film's main ideas. Specifically, these are cinematography, mise-en-scène, editing, and sound. While all four are employed in significant ways to support the film's narrative, they also communicate in a very direct way the emotions, atmosphere, and symbolism that support the film's aforementioned three main ideas. To understand how this comes about, we must examine Kubrick's use of each technique in greater detail.

Cinematography: Kubrick's decision to shoot with 65 mm film yielded an image that is stunningly real on the screen. Even today, no other medium can come close to its level of resolution. Consequently, the audience is drawn into *2001*'s fictitious, futuristic world more easily and can more readily accept it as reality. With its wide 2.21 to 1 aspect ratio combined with projection on a large screen, the 70mm release print[16] offers unrivaled resolution and an image that is an overwhelming spectacle. Framing faithfully places what Kubrick deems most important at center stage. Such shots often include tools, instruments, and displays and reveal an unprecedented level of detail. The angles from which the spacecraft are photographed repeatedly emphasize their grandeur and what a marvel of engineering they are. Close-ups of the surfaces of spacecraft and landing facilities reveal intricacies of their structure that enhance the realism of these shots to a degree far beyond that seen in any previous science fiction film. Realism is further enhanced by process shots or miniature movies that have been rephotographed and placed within the frame. These are shots of interiors seen through windows or view ports such as the shots of the windows in the docking bay of the space station where we see the crew monitoring the approach of the Orion in Act II. Not only did this technique contribute to the realism of scenes involving spacecraft and landing facilities, but it also gave the audience a dramatic sense of the scale of these structures and how they dwarf their human occupants.

During Acts III and IV, Kubrick uses both the subjective camera and special wide-angle lenses to great effect. In Act III, the distorted images we see from Hal's point of view and frequent close-ups of Hal's electronic eye convey the impression that he is both an omnipresent as well as omniscient

presence aboard the Discovery, but more importantly, that he is a character that needs to be watched more than trusted. In Act IV, both the point-of-view shots and distortion created by the lens help us empathize with Bowman's "stranger in a strange land" experience as he explores the alien suite. Notice the long shot of Bowman when he first stands in the alien bedroom. The surroundings look familiar, yet through the lens both space and time are distorted, lines that should be parallel are curved in this place. We sense, as does Bowman, that things in the alien world are not normal or real in the sense that we understand reality.

Most importantly, Kubrick mastered the art of the moving camera in a way that gave us scenes which were more than merely dynamic. Kubrick's and cinematographer Geoffrey Unsworth's innovative cinematography has given us scenes in which motion relative to the subject is so well integrated with the music that the aesthetic effect of both is greatly amplified.

Mise-en-scène: Regarding the various sets and properties which include spacecraft exteriors and interiors, the moon base, docking facilities, and the lunar landscape, all obtained a level of realism never reached before and rarely matched in any science fiction film since the advent of *2001*. The same can be said for the shots involving crew personnel moving and working in zero gravity. The impact that this technique had on audiences was not lost on directors of future science fiction films. After *2001*, exterior and interior sets as well as properties became far more detailed and realistic in science fiction films involving space travel.

Mood lighting and the use of tones and colors in general emphasize the collective thinking processes during the eras of

human evolution. Earth tones and blue skies dominate in the time of the primitive ape-men when instinct begins to evolve into intuition. By the twentieth century, ape-man has evolved into computer-man living in a world of divalent logic with zeros and ones reflected in the absolutes of black and white in outer space. To move beyond this, Bowman must pass through a tunnel/threshold of contrasting colors where he encounters the world of the superintuitive aliens. In this realm, intellect has evolved beyond machine logic as the aliens seem to control their environment by thought alone. Kubrick may have also used color to suggest a link between Hal's electronic eye and the danger that arises from his paranoia. The red seen in the lens of Hal's eye is rarely used on the sets in *2001* with one prominent exception, the interior of Hal's nerve center which we see only when Bowman proceeds to terminate him.

The behavior and dialog of the human characters remain vapid throughout the middle sections of the film. By Act III, the behavior of Poole and Bowman stands in stark contrast to the behavior of Hal, making them appear dull, wooden, and uninteresting as individuals. Poole's zombie-like appearance and behavior during the scene in which he receives the birthday video from his parents provide a striking example. This strategy emphasizes the reciprocal relation between the evolution of the machines and the evolution of the human race as one becomes more machine-like while the other appears more human. By directing his actors to behave this way, Kubrick underscores their character's need to rediscover their intuitive ability and revive their humanity. We also see that by not letting us come to know the characters in depth, Kubrick brings out their mythological dimension wherein the characters in their various roles and times need to be seen as

representatives of an evolving race in a drama that is far more about the race than it is about any individual.

Tools and technology play a strong supporting role in the narrative, stealing many of the film's scenes, allowing us to see them as characters more than we normally would. Hal, in particular, is far more than an advanced computer assisting with operations on board the Discovery. He is a talking, thinking, feeling machine who is in every way a principal character in the story, as well as its most sinister villain. Some writers have gone so far as to claim that, with the exception of Floyd's daughter, Hal is the most human character in the film. However, I don't find this an accurate description of what we see during the plot, nor is it in keeping with Kubrick's futuristic myth. Hal appears to express more emotion than Dave or Frank, but the emotion in his responses sounds programmed. It is as if we are hearing what someone thinks would be the most appropriate emotional response to the dialogue and behavior of his human crewmates. Up until his life-and-death showdown with Dave, Hal's dialog is more a calculation than conversation possessing any spontaneous or genuine human feeling. Hal also proves to be emotionally unstable, but animals exhibit emotions and emotional instability also, so this is not a uniquely human trait. While Dave Bowman is reserved and doesn't exhibit much emotion until his conflict with Hal, he was the artist in the crew, not Hal; and we need to ask, where were Hal's humanity and feelings for Mr. and Mrs. Poole when he methodically and cold bloodedy murdered their son along with three other crewmates who were no threat to him? To his end, Hal never shows any genuine remorse, only fear of being terminated. Certainly, Hal is a highly significant character and his cunning and highly devel-

oped artificial intelligence makes him a formidable antagonist to Bowman. However, without the benefit of repeated viewing, many might miss the way in which the subtleness and restraint of Keir Dullea's portrayal of Bowman allows us to see that beneath the cool, professional surface of this character lies a complex and truly human personality. While Hal calculates, analyzes, and reacts, Bowman reflects, creates, and foresees. In Dave Bowman, Kubrick has fashioned a character that has the qualities necessary to triumph over the machine and move on to the future.

Editing: Cuts that span huge gaps in time in *2001* might seem to make the film overly episodic or even fragmented. However, in a story spanning millions of years, cutting together large sequences that are spaced widely apart in time helps us to understand that the ape-men, Heywood Floyd, David Bowman, and the Star-Child make one super character with a role that spans the entire narrative. Graphic match cutting from the bone-tool to the man-made satellite links the two in a way that underscores the astounding transformation that evolution has brought about as we witness it all from a God's-eye view. A simple cut also serves as the transition from Dave's awakening from a state of shock at the end of the light tunnel sequence to his disorienting arrival at the alien suite. Using the cut as a transition impels us to form associations between the images and scenes more than dissolves or other elliptical transitions would. Near the end of the film, jump cuts defy cause and effect and undermine conventional continuity, helping us to empathize with Bowman's fear and bewilderment in an alien world. The jump cuts also add considerable ambiguity to the question of how much time Dave has actually spent in the alien suite. His stay could have been for a few minutes or many Earth years.

Shot duration or timing of cuts and subject movement are two of the most important elements that determine the pacing of any film. In *2001*, many shots such as those of spacecraft exteriors and interiors are held for a much longer time than would be necessary for showing narrative action or establishing setting. However, this additional time allows us to enjoy the formal qualities of the shot and contemplate the progress of the subject's evolution. The gradual transitions from black allow for reflective associations between sequences where the human race has been largely marking time rather than making dramatic leaps as in the transition from the rising sun in the opening title to the rising sun at dawn in the desert and from the prehistoric monolith unearthed on the moon to the fossil-like Discovery drifting towards Jupiter. Duration and timing of transitions is essential for both the abstract sequences and the dance sequences (e.g. the beginning of Act II). Image form and movement from cut to cut must flow in rhythm to the music or the scene would immediately loose its emotional and aesthetic impact.

Sound: Kubrick's emphasis on the sound of Bowman's steady breathing as he reenters the Discovery at the end of Act III underscores the character's effort and determination to survive Hal, but on an allegorical level suggests a resuscitation of the human spirit that has begun to take place. However, no other stylistic device in the film contributes more to the tone of the images on the screen than the music Kubrick selected. To recapitulate, "The Blue Danube" celebrates the precision, grace, and triumph of man's technology. Ligeti's music, particularly *Requiem* and *Lux Aeterna*, evokes a sense of mystery, eeriness, and awe the characters feel as they encounter the work of super-intelligent, extraterrestrial life.

By the beginning of Act IV we realize how both the radiant tone clusters of *Requiem* and the luminous angelic voices of *Lux Aeterna* have become the themes that have introduced the deep, cosmic mysteries in *2001*. Yet, as "*Lux Aeterna's*" title would suggest, when the human race addresses these mysteries the protagonists move into light. In fact, the protagonists and we as members of the audience are constantly moving into light throughout the odyssey, never into darkness. A third Ligeti composition, *Atmospheres*, accompanies Bowman's dazzling intergalactic ride to the alien world. Ligeti's brilliant atonal orchestration structured solely on the basis of instrumental timbre communicates the strange and marvelous quality of Bowman's journey and integrates perfectly with the flow of Kubrick's patterns of light and color.

The brooding, sorrowful "Adagio" from Khachaturian's *Gayane Suite* heard at the beginning of Act III signals that something isn't right on board the Discovery and foreshadows something dark and tragic may lie ahead for the crew. Indeed, if we look back on the events that unfolded in Part I of Act III as a whole, the "Adagio" becomes a requiem for the death of the human spirit. This idea is brought out poignantly with a twist of Kubrickian irony in the scene where Frank watches his parents struggle to celebrate his birthday back on Earth. The "Adagio" (non-diegetic music) is overlaid with Frank's parents singing "Happy Birthday" (diegetic music). The effect this combination of the two pieces of music creates is sad and disturbing. Add to this the irony of Hal's artificially sweet voice and you have a milieu that completely underscores Frank's dehumanizing detachment. Music and sound effects are used to create irony again when the perfect, more human-than-human machine, after breaking down and committing murder, offers us a love song

as it watches itself being terminated. Written in three-quarter time, "Daisy Bell" recalls "The Blue Danube" that opened Act II, but this is no celebration for the machine. "Daisy Bell's" whimsical lyrics, sung by Hal as his brain is disconnected and voice becomes slower and much lower in pitch, reduce this once-intellectual titan to something that sounds like a child's broken toy.

Finally, the opening chords of *Also Sprach Zarathustra* which open and close the film evoke a sense of majesty, awe, and optimism at those seminal moments when humans celebrate the triumph of their inventiveness, stand before a threshold to a new adventure, or contemplate their destiny. These examples demonstrate that Kubrick has used music, particularly non-diegetic music, in a way that goes far beyond the common convention of providing some background atmosphere or supporting the emotional side of the narrative. Music informs *2001,* and through motifs, systematically cues us to understand better its symbolism and ultimately its grand ideas. Music paces the scenes and transitions between scenes throughout the film from the opening title to the shot of the Star-Child at the end of the film. Music and the images choreographed to it work on us directly, whereas words from characters and their facial expressions simply wouldn't be enough. Kubrick understood that even with the best actors these would fail, becoming a kind of emotional noise that would distract from, rather than add to, the power of the scenes.

Scenes where techniques of style are integrated to work in concert to evoke a response or communicate an idea are the ones that have the greatest impact. This is particularly true of the many motifs that occur during the film such as the align-

ment of three celestial objects or two celestial objects and the monolith. Here cinematography, mise-en-scène, and sound work together to create a profound impact on the viewer. At the most general level, this pattern is communicating the idea that specific and rare celestial alignments signify critical or special moments in time which possess a quality or meaning in synchronization with the quality and meaning of what the human race is experiencing at that time. Mise-en-scène gives us the alignment and triad; cinematography supports the significance of the pattern using camera angle, image size, and high resolution film stock. The music in the soundtrack reinforces the triadic structure while capturing the tone and emotion of the moment.

A spectacular example of Kubrick's use of all four techniques of style working in concert may be seen in the series of shots that open Act II. Make no mistake about it, this is a dance sequence and every move was painstakingly choreographed to the music (sound). Camera movement and subject movement are exquisitely timed so that we feel the joy of a celebration as spacecraft waltz to "The Blue Danube." Camera angle, image size (cinematography), lighting, color, blocking, and set design (mise-en-scène) enhance the communication of this feeling even more. Selection, duration, and timing of the cuts (editing) from the satellites to the earth, moon, space station, and the shuttle allow us to take in all the various participants in the dance while maintaining the proper overall pace the sequence requires.

While this is not an exhaustive treatment of Kubrick's style, I have tried to offer some detail on the more salient elements and techniques employed in *2001* with the hope that this will be sufficient to persuade the reader that it is *2001*'s

style which gives unity to the film's diversity of forms. Style carries the themes of *2001*. Through its 65mm cinematography, set design, patterns of color, editing, music, the motion of objects synchronized to music, and most importantly, the shared meaning of the objects in motion with music, *2001* consistently conveys the idea that the future is really happening; that man's tools will evolve to a state of majestic beauty and attain artificial intelligence; and that our evolution, the evolution of our technology, the exploration of space, and the possibility of encountering alien life are awesome, soul-jolting experiences. Amidst all of its extraordinary detail and visual information, *2001*'s style with its motifs, archetypes, and super motifs keeps us focused on the broad strokes so that we never lose sight of the forest for the trees. Kubrick has reminded us of the evolution of cinema itself which began as a way of telling stories using images and music whether played live or from recorded media. Kubrick's style demonstrates that these techniques remain viable and effective to the present day.

Final Questions and Conclusion

We have seen how patterns, archetypes, and style not only inform *2001: A Space Odyssey*, but communicate essential information related to both its story and Kubrick's three main ideas. However, Kubrick does not explain everything and a number of tantalizing mysteries and unanswered questions remain.

The function of the monolith has probably been the most debated mystery in the film. Most likely, it was placed on Earth and the moon to serve as a monitoring device because

the aliens would have needed a means to keep track of our progress until we evolved to the point where they felt it necessary to bring a representative of our race to their world for closer study. Yet, many writers and viewers believe its role was much more active. They maintain that the monolith was a device that the aliens used to alter human thinking, if not human evolution, pointing out that it is present at four very critical times during the plot. I believe the best way to ascertain the function of any element in a film is first to study its use in the film itself.[17] We can rule out coincidence because a correlation between the appearance of the monolith and key events in the history of human evolution definitely exists and Kubrick has placed it very prominently and dramatically within his film. There is no evidence of any mechanism bringing about changes in either the apes or the humans or even communicating messages to them, but this cannot be ruled out. However, Kubrick may have been suggesting that the relationship between human evolution and certain rare celestial alignments was synchronous and that the aliens had knowledge of such phenomena. Synchronous relationships between events are those that are acausal, in certain situations repeatable, and possess some quality or meaning in common.[18] This commonality may also extend to periods of time which in turn may be signified by the periodicity of specific celestial alignments. Suggesting that synchronous relationships could explain critical points or shifts during the course of human evolution would have been an extraordinary insight on Kubrick's part. He also implies, through the behavior of his characters, that twentieth-century science has been largely unaware of these ideas. Steeped in the deterministic, cause-and-effect scientific method of the twentieth century, people like Heywood Floyd, Dave Bowman, or even

Hal would have regarded this kind of thinking as a radical departure. In this sense, Kubrick has anticipated a new paradigm for twenty-first century science, one that could embrace the significance of time-dependent, acausal phenomena.[19]

A second mystery is the mission or purpose of the Star-Child. Everything points to the likelihood that he represents a new step in the process of human evolution which, in Kubrick's view, seems closely allied to the holistic idea of evolution being a process unfolding in "positive" or "creative" time, as Bergson characterized it. The following quote from an article on holism authored by philosopher Jan C. Smuts is enlightening:

> Wholeness or holism characterizes the entire process of evolution in an ever increasing measure. And the process is continuous in the sense that older types of wholes or patterns are not discarded, but become the starting points and the elements of the newer, more advanced patterns. . . . The whole is creative; wherever parts conspire to form a whole, there something arises which is more than the parts.[20]

I think it is safe to assume that the Star-Child has great potential to alter things on Earth. Given Kubrick's philosophical leanings, we might speculate that the Star-Child will serve as a liaison between humans and the aliens. Perhaps he will show humans how to build even greater machines, or save humans from being dominated by their machines. Some might argue that a darker end is at hand. Yet, while destruction, decay, and death remain a part of the human odyssey, which Kubrick has not failed to show us, nihilism is not a theme in *2001*. Indeed, we have witnessed a resurrection at the end of the film, a resurrection/rebirth indicating the most

likely mission for the Star-Child will be the re-humanization of the human race.[21]

While any of the aforementioned alternatives could serve as a possible epilogue, open endings remain unsettling for some viewers. However, a story about evolution is necessarily about a continuing process that may have no end. Thus, Kubrick's ending serves his story better than the alternatives; it maintains our curiosity.

A number of writers have commented on the film's raising questions about free will and whether humans or the aliens are really in control of the destiny of the human race.[22] While events in the fourth act strongly imply that the aliens acted, at least, as midwife in the birth of the Star-Child, this is not the same thing as determining destiny nor does it preclude free will on the part of this new species. There is simply no evidence that either the ape-men or the Star-Child were reprogrammed to behave or think according to some one else's plan with no free will of their own. Again, judging by the film itself, Kubrick has avoided giving us a firm answer, but screenplay co-writer Arthur C. Clarke offered insight into Kubrick's intentions in a general way when he stated, "If you understood *2001* completely, we failed. We wanted to raise far more questions than we answered."[23] Certainly, Kubrick and Clarke understood that their hindsight was much greater than their foresight. In the aforementioned instances where *2001* does not offer us solid answers through dialog or text, the patterns, motifs, and archetypes continually express an attitude that is positive and hopeful. In the end, mysteries not withstanding, *2001*'s images and music leave us filled with a sense of wonder.

The difficulty some viewers and critics had in under-

standing and/or appreciating *2001* that I referred to at the beginning of this essay most likely stems from Kubrick's deviations from the conventions of the genre and what is known as "classical Hollywood mode" of narration.24 The film's complex formal system and the allegorical quality of the story are two examples. While neither use of a complex formal system nor allegorical narration was new to film by the late sixties, Kubrick's innovative combination of these strategies was more than American audiences were prepared for. It was something they might have expected to see in foreign art cinema, but not in an American science fiction film.

A third important cause of audience dissatisfaction was Kubrick's avoidance of accepted norms of expression in *2001*, particularly expression through character behavior. By the early sixties, American-made science fiction films had developed a strong set of conventions.25 If anything mysterious, incomprehensible, or spectacular occurred, audiences expected to see the main characters talking about it, expressing their feelings, and sharing their thoughts. Because Kubrick reduced these forms of expression to a minimum and told his story in a way that avoided focusing on any one character as the protagonist, many left the theater feeling the film was incomplete and unsatisfying. For some, the method in Kubrick's madness took time to grasp. Most directors would have followed the traditional path of communicating ideas and emotions through actors who act out their character's reaction to an extraordinary event or experience. However, by minimizing traditional character behavior, dialog, and voice-over narration; Kubrick's style allowed striking visuals, archetypal symbols, and music to shine through, hitting us directly and intensely where our aesthetic sense grasps the essence of his ideas. Had he relied on actor's

expressions and emotional responses, much of the impact would have been lost owing to the indirect interpretation of the event we get through the actor's portraying the character's response. This is similar to listening to a person's describing Michelangelo's statue of David or a performance of Stravinsky's *Le Sacre du Printemps*. No matter how descriptive the language or how much emotion the person is able to express, the experience would not be the same as viewing the statue or listening to the performance in person. The aesthetic impact is missing.

Even today, few films from any genre can be compared to *2001* in this regard. Kubrick's mode of narration demands a greater awareness of symbols, archetypes, and style because it is through these that he reveals the film's themes. *2001* also requires a greater sensitivity to music and the non-representational or abstract visual arts because the film's aesthetics work on these as well as traditional narrative levels. While Kubrick doesn't offer a how or why for some of the more significant events in the film, neither does he give us the studied ambiguity often observed in foreign art cinema. If the answers are not available in some form of text there is certainly an abundance of symbols and associational links to keep our minds engaged and provide us with clues. Rather than merely thwarting our expectations, whether they derive from our experience with the science fiction genre or classical Hollywood mode of narration, Kubrick's style constantly reinforces *2001*'s symbolic imagery, allowing us a variety of opportunities to form associations, interpret them, and draw our own conclusions. Through his consistency, Kubrick encourages us to discover a new path to meaning in narrative film. He gambled putting his ideas and what he called "the feel" of his film ahead of character and story, but Kubrick's

overall intentions were never truly obscure and are perhaps best summed up in the following quote: "What I'm after is a majestic visual experience."26

For my final topic, I will take a closer look at what I believe is Kubrick's most original and important innovation to both the science-fiction genre and narrative film in general. This is a stylistic technique that I have referred to earlier as music-driven imagery in *2001: A Space Odyssey*. We need to replace this rather vague phrase with one that is more precise and scientific. My term for this kind of phenomena is *musicography* or the *musicographic image*.27 A musicographic image is one in which the formal or abstract qualities of the image such as subject size, color, velocity, shape of path, speed of rotation, darkness or lightness are integrated with the music so completely that the aesthetic experience of the audience is amplified non-linearly. I should make clear that musicography is not the same as the phenomena known as synesthesia or chromesthesia. These have been investigated and defined as phenomena that occur within the subject's mind when listening to music.28 Musicographic images are created outside of the mind and perceived through our senses of hearing and sight. Although a thorough discussion of this fascinating topic would be far beyond the scope of this essay, I hope to give the reader a basic idea of the concept and its importance to film and art in general.

Given its intense aesthetic impact, the musicographical image is easy to recognize, but difficult to describe in words. As a phenomenon better understood through demonstration rather than explanation, I would encourage the reader to review and study three prime examples in *2001*: the opening title, the Orion's voyage to the space station that opens Act II, and the light tunnel sequence in Act IV. Hopefully, as it

becomes better understood, the use of musicography will expand in film and other visual media in the future.

2001's opening title clearly demonstrates that timing and rhythm of movement of the visual components are extremely critical in the presentation of a musicographic image. The title begins with an extremely deep organ note, the first note of *Also Sprach Zarathustra*. Observe how this is integrated with the dimness, visual mass, and velocity of the celestial bodies as they begin to rise. Accompanying their ascent are the first three notes of the fanfare, C G C8va. This is punctuated by a C minor chord, just as the brilliant light of the sun breaks over the earth's horizon. The visual image reinforces the great tension created by the sudden major to minor chord change at the end of the first fanfare. The second fanfare ends on a brighter, C major chord, as the sun continues to rise shedding more light on the scene. At the beginning of the third fanfare the words "Metro-Goldwyn-Mayer presents" burst on the screen in white letters balancing and establishing a base of brightness towards the bottom of a form that has evolved into a pyramid. The sun has now risen three quarters of its diameter above Earth. As the fanfare comes to a climax with a triumphant F major chord and a cymbal crash, the second, larger credit, "A Stanley Kubrick Production," flashes across the screen. The full orchestra now plays the final part of the theme returning to the original key of C major, climaxing with a greater cymbal crash, as the title *2001: A Space Odyssey* explodes out to the full width of the screen in still larger white letters with the full sun crowning the top the triangular form. Having ascended to the light, the final C major organ chord reverberates and fades as the image likewise fades to black for the transition to the first act.

The opening sequence of Act II presents some of the film's most exquisite choreography, but to see this sequence musicographically we must look at its shots more as abstract compositions than representational cinematography. Observe the abstract qualities of the spacecraft in these scenes, specifically their shape, velocity, rate of rotation, and light color against the black background of space. The sequence begins with a shot of a satellite in orbit around Earth as Strauss' "The Blue Danube" waltz begins slowly and quietly. At first, everything seems to be drifting including Floyd's pen. Gradually, as the waltz rhythm of the music is asserted, the various subjects of the shots take up the dance as their speed and rotation are synchronized with the rhythm. In subsequent shots both the speed of the camera pull-backs and the Orion gliding across the screen or deeper into the background are closely integrated with the gliding movement evoked by the waltz. In the second triad formed by the space station, the moon, and the Orion, notice the speed of rotation of the wheel-shaped space station and the Orion gliding to it – both in synchronization with the three-quarter meter of "The Blue Danube." As the music swells, Kubrick cuts to a side view of both spacecraft and these two shapes loom much larger on the screen. In the next shot, the waltz reaches its crescendo as the camera tracks in even closer, moving within the outer rim of the rotating station. The dramatic climax of the expanding white rotating mass and the music is perfectly integrated.

The light-tunnel sequence begins as Bowman's space pod approaches the complete blackness of the rectangular threshold with Ligeti's *Requiem* rising in the sound track. After he enters the abyss, the first streams of colored light

pass by, creating a sense of rapid acceleration through a great distance. Patterns of brilliant, streaming colors shoot out at us intercut with shots of Bowman's face shaking with patterns of color from the illuminated instrument console reflected off his visor. The shaking increases to a vibration that becomes so rapid that Bowman's features eventually merge with the vibrating patterns of color on his visor. The notes and dissonant harmonies performed in Ligeti's music resonate and stream out at the viewer as do the vibrant waves and shards of contrasting colors. As the music swells and the multiple, often dissonant tone clusters sung by the chorus clash and shatter, the patterns of light also swell and shatter into multiple colors. *Requiem* then transitions to *Atmospheres* and we flow through planes and streams of fluid color on to the beginning of creation and the birth of galaxies as they expand and flow in time. Overall, we experience a metaphor in color, form, and music for Bowman's and our astounding journey through space and time to the world of the aliens.

For a small but significant fraction of the audience, the intensity of this kind of aesthetic experience exceeds the impact of anything that could be felt as the result of either the images or the music acting alone. It is direct, stunning, and mesmerizing. Yet, exposure to this kind of imagery was still a very new experience for most members of the film-going public. Musicographic images had not been used in any science fiction film prior to *2001*, although they had been attempted in some experimental work such as the abstract films of Mary Ellen Bute as well as some of the animation and dance films of Norman McLaren. There was, however, one notable exception among films distributed for general theatrical release, Walt Disney's *Fantasia* (1939).

Considering the thought and intention behind Kubrick's work, we can see how *2001*'s imagery derives more from *Fantasia* than from any earlier science fiction film or drama. *Fantasia* also mixed narrative with abstract form during its plot; however, its plot was deliberately divided into a number of distinct animated episodes. Its unity of form derives from Disney's original conception that each episode drawn by the film's animators would be inspired by the piece of classical music selected for its soundtrack. Comparing the films with each other as a whole, however, many of the scenes in *2001* were also composed to the music used in the sound track and both are about and succeed because of the successful orchestration of visual images and music together. Unfortunately, neither the talent of Disney's team of animators nor Kubrick's talent and success with this technique has yet to be grasped by the majority of film critics, film historians, or filmmakers. Consequently, both films remain unique, isolated, and underappreciated for their special contribution to films made for general theatrical release.

Kubrick did receive letters from members of the audience who were deeply moved by his musicographic images. A response that was particularly creative and perhaps the one that had the greatest impact on Kubrick was written by Stephen Grosscup of Santa Monica, California. The following excerpt represents a fraction of the original letter, yet it conveys Mr. Grosscup's main insight and a description of his creative project that Kubrick's work in *2001: A Space Odyssey* inspired.

Quoting from Stephen Grosscup's letter:

> It's a film of incredible irrevocable splendor. . . .
> What if, I thought, someone wanted to see

Beethoven's Ninth Symphony? Would you show them an orchestra and a chorus? Or what? Then I thought, what if someone filmed music? What if I filmed music? I went out and filmed the third Movement of Gustav Mahler's Seventh Symphony. It worked. It worked beautifully. . . . it is doubtful that ever in my own lifetime will I be able to shoot a natural scene involving three planets. I knew instantly that you had too much reverence for Richard Strauss to tamper with the score – which meant that you had to put the film to the music – and you did – three times! . . . I have since done a great deal of thinking – and preparing – about 'filmed' music. I have gone so far as to envision a day when there will exist a new kind of artist who is both composer and photographer and who brings about a new form of art. But that day I think is a long way off, but maybe by the year 2001 . . . [29]

Stanley Kubrick's response: "Your letter of May 4th was overwhelming. What can I say in reply?"[30]

Indeed, Stephen Grosscup really got it. His insight is as original and remarkable as it is far-sighted. He has paid Kubrick the highest compliment a filmmaker could ever be paid. I leave you with the thought that we are not at the end of this journey; rather, we are standing before a new threshold.

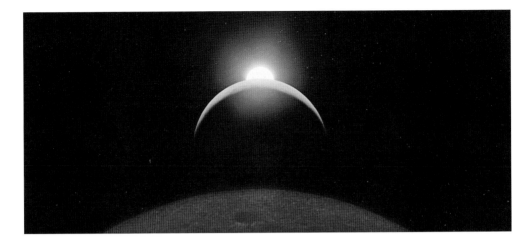

1. The earth and sun rise above the moon to form the first triad.

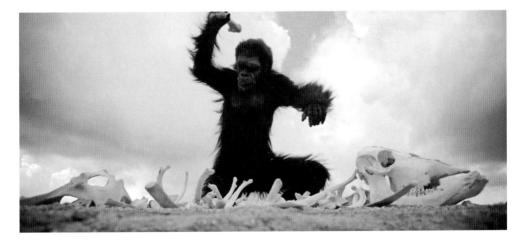

2. Moonwatcher discovers a bone may be used as a tool.

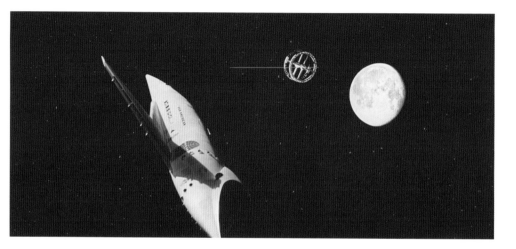

3. The Orion completes a triad as it glides to the space station.

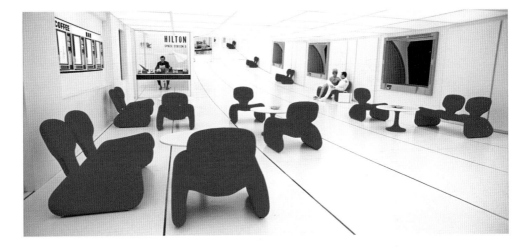

4. The rather stark interior of the hotel lobby inside the space station.

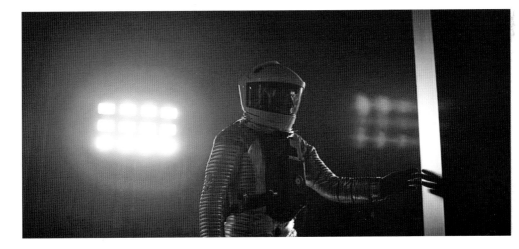

5. Heywood Floyd touches an alien artifact and his past.

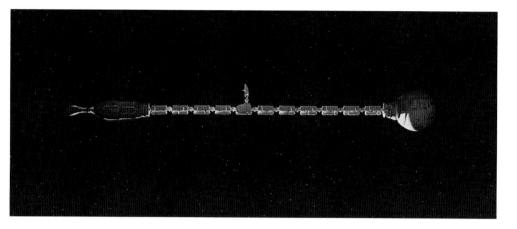

6. The fossil-like Discovery drifts towards Jupiter.

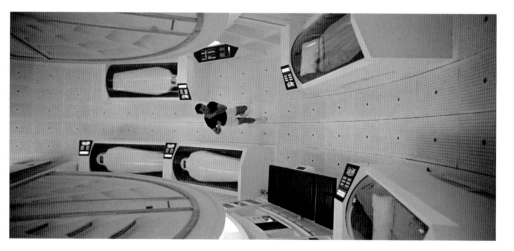

7. Frank Poole passes his sleeping comrades as he runs in circles boxing with an invisible opponent.

8. Hal lures Dave into a conversation and the second "chess game" begins.

Illustration 8 C-5

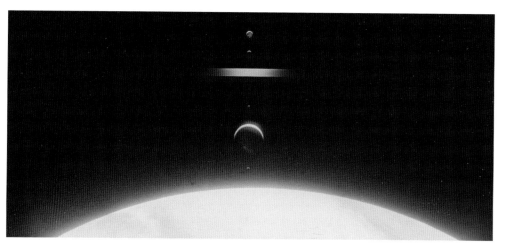

9. Jupiter's moons align with the monolith.

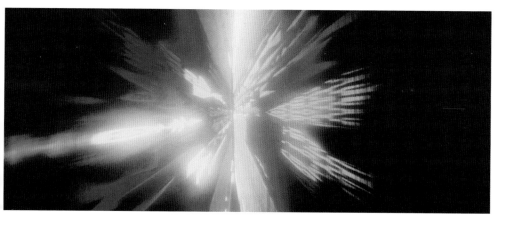

10. A voyage to another galaxy at superluminal speeds presents us with sights unlike anything we have seen before.

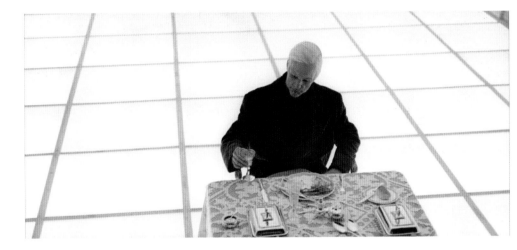

11. Dave Bowman's elegant last supper.

Illustration 11 C-7

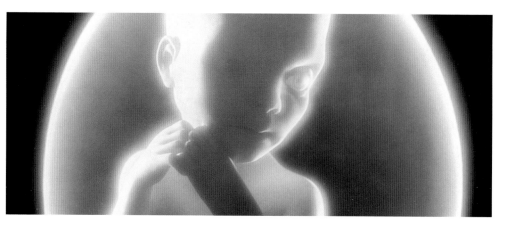

12. The Star-Child gazes down on the earth.

Appendix A

Film Credits for 2001: A Space Odyssey

Director and Producer	Stanley Kubrick
Screenwriters	Stanley Kubrick and Arthur C. Clarke
Director of Photography	Geoffrey Unsworth
Special Photographic Effects	Wally Veevers, Douglas Trumbull, Con Pederson, and Tom Howard
Editor	Ray Lovejoy
Production Design	Tony Masters, Harry Lang, and Ernest Archer
Art Direction	John Hoesli
Sound	Winston Ryder
Costumes	Hardy Amies

Cast

Dave Bowman	Kier Dullea
Frank Poole	Gary Lockwood
Heywood Floyd	William Sylvester
Moonwatcher	Daniel Richter
Hal's Voice	Douglas Rain
Andrei Smyslov	Leonard Rossiter
Elena	Margaret Tyzac
Halvorsen	Robert Beatty
Floyd's Daughter (Squirt)	Vivian Kubrick

Appendix B

Production Facts About 2001: A Space Odyssey

Production Company: Metro-Goldwyn-Mayer

Production Location: MGM British Studios, Ltd., Borehamwood, England

Date Production (Principle Photography) Began: December 29, 1965

Original Release Format: 70mm, Cinerama Super Panavision 70

Color Process: Technicolor and Metrocolor

Date of Release: April 2, 1968

Date of Release for Final Edited Version: April 9, 1968

Academy Awards Received: 1968 Oscar for Special Visual Effects

British Academy Awards Received: Geoffrey Unsworth for Best Cinematography

Tony Masters, Harry Lang, Ernie Archers for Best Art Direction

Winston Ryder for Best Soundtrack

Other awards: Italy – The Di Donatello Statue for the Year's Best Film from the West

Appendix C

The Cinerama Super Panavision Process

Principle photography for *2001: A Space Odyssey* was recorded on 65mm color negative film stock which after editing, optical effects, addition of the sound track, and other post-production processes was used to produce a 70mm release print for distribution to theaters. The release prints were to be projected in a format known in 1968 as Cinerama Super Panavision 70.

By 1965 the original projection format for wide, curved screens known as Cinerama had evolved into three offshoots that were used in theatrical projection: Super Techirama 70, Ultra Panavision 70, and Super Panavision 70. Super Panavision 70 was projected from a 70mm release print using spherical lenses onto a curved screen with an aspect ratio of 2.21 to 1. It also offered six magnetic tracks of stereo sound. These prints could also be projected in theaters with flat screens though the surround effect created by the slight cur-vature of the Cinerama screen was absent.

An anamorphic 35mm print with a 2.35 to 1 aspect ratio was also released at a later date for theaters not equipped for 70mm projection.

For a detailed history of wide screen formats such as Cinerama and Super Panavison 70, see John Belton's *Widescreen Cinema* (Cambridge: Harvard University Press, 1992), 85.

Notes

1 Schneider, Michael S., *A Beginner's Guide to Constructing the Universe* (New York: HarperCollins Publishers, Inc., 1994), 39.

2 Schneider, 38.

3 The titles I have used for Acts I and IV are identical to those used in the film. The titles for Acts II and III were added by the author to suggest an interpretation of the act's main events or a possible premise.

4 One of four major techniques of style that comprise a film's stylistic system, mise-en-scène is a French term used in theater to describe how scenes are staged. In film production it includes lighting, set design, character behavior, blocking, properties, costuming, hairstyle, make-up, and any other staging techniques used in front of the lens during production.

5 When discussing plot in a film, I am referring to all of the events both diegetic (from within the story world) and non-diegetic that take place on the screen in the order in which they are presented. When discussing plot as defined in literature, I shall refer to it as literary or story plot.

6 The voices, or to be more precise, the vocal utterances heard in this sequence are from a short, music-theater composition by Gyorgi Ligeti titled *Adventures* that did not appear in the film's credits. Roughly ninety seconds of *Adventures* was apparently edited, filtered, and remixed to create an otherworldly accompaniment to Bowman's walk through the alien suite.

7 ". . . the second law of thermodynamics is related to the fact that some processes are irreversible; that is, they go in one direction only. However, there are many irreversible processes that are not easily described by the heat engine or refrigerator statements of the second law. Examples are the free expansion of a gas or a glass falling off a table and shattering when it hits the floor. . . . There is a thermodynamic function called entropy S that is a measure of the disorder in a system. . . . In an irreversible process, the entropy of the universe increases." Paul A. Tipler, *Physics for Scientists and Engineers*, 3rd ed. (New York: Worth Publishers, 1991), Vol.1, 576.

8 R. Feynman, R. Leighton, and M. Sands, *The Feynman Lectures on Physics* (New York: Addison-Wesley Publishing, 1963), Vol. 1, 46–47

9 ". . . the entire universe is in a glass of wine, if we look at it closely enough." R. Feynman, ibid., 46–48.

10 I am much in debt to David Bordwell and Kristen Thompson for the concepts and definitions of terms put forth in their excellent text, *Film Art – An Introduction,* 4th ed. (New York: McGraw-Hill, Inc., 1993).

11 Ibid., 492.

12 Ibid., 492.

13 I have called these sections acts based on the four divisions in the screenplay originally labeled A, B, C, and D by authors Kubrick and Clarke. Each stands as a unit of dramatic action which takes place at a different time in a different location.

14 Some writers have referred to the Dawn of Man section as a prologue; however this term may lead to misunderstanding the film's story plot. I prefer to call The Dawn of Man section the first act of the film. A prologue would usually offer either a voice-over or text which would introduce the story, but these are absent and this section offers much more than a simple introduction or preface to the film's story. The first

representatives of the human race including the main character (referred to in the screenplay as Moonwatcher) are introduced along with the adversities presented by their environment. By the end of the first act (the first plot point) the first sign of extraterrestrial intelligence has appeared (the monolith) and ape-man has begun his ascent to modern man and invented his first tool so both the dramatic situation and the path of the protagonist have been established.

15 Joseph Campbell, *The Hero with a Thousand Faces,* (Princeton: Princeton Univ. Press, 1949; reprint ed. New York: MJF Books), 245.

16 The original release format was Cinerama Super Panavision 70. See Appendix C for more information about this process.

17 It is important to bear in mind that while Clarke's earlier short story, *The Sentinel,* inspired the story for *2001* and was the source of some of the ideas seen in the film, it was never Kubrick's intention that the screenplay be an adaptation of this work. The dialog and events that occur in the film vary considerably from what was written in the *Sentinel* and earlier versions of the screenplay.

18 Victor Mansfield*, Synchronicity, Science, and Soul-Making* (Open Court Publishing, 1995), 22.

19 L. von Bertalanffy, "General System Theory," *Main Currents in Modern Thought* 71, 75, 1955. See also R. Feynman et al, *The Feynman Lectures,* Vol. III, Philosophical Implications, 2–8.

20 *Encyclopedia Britannica,* ca. 1936, "Holism," by Jan Christian Smuts.

21 Campbell's description of the hero's return also supports this: "the hero has died as a modern man, but as eternal man – perfected, unspecified, universal man – he has been reborn. His second solemn task and deed therefore . . . is to return then to us, transfigured, and teach the lesson he has learned of life renewed." Campbell, *The Hero with a Thousand Faces,* 20.

22 Phil Hardy, ed., *Science Fiction* (New York: William Morrow and Co., Inc., 1984), 279.

23 Jerome Agel, ed., *The Making of Kubrick's 2001* (New York: Signet/The New American Library, 1970), 367.

24 David Bordwell, *Narration in the Fiction Film* (Madison: University of Wisconsin Press, 1985), 157.

25 To mention a few of the most common conventions prevalent in science fiction films of the post-WW II era that are not found in *2001*: the protagonist or hero was usually played by one character, there was often a subplot involving a romantic relationship between the leading male and female characters, exposition usually came from character dialog, aliens were viewed as a threat to humans and the earth, and the style of spacecraft, properties, and costumes took precedence over making them look realistic.

26 Agel, *The Making of Kubrick's 2001,* 113.

27 Albert Halstead, "Towards a Theory of Musicography" (unpublished treatise and notes, 1972).

28 Theodore Karowski and Henry Odbert, *Color-Music*, in *Psychological Monographs*, ed. John F. Dashiell (Columbus: The Psychological Review Co., 1938), vol. 50, no. 2.

29 Agel, *The Making of Kubrick's 2001*, 190.

30 Ibid., 192.

Index

Jupiter 14, 17, 18, 26, 35

Kachaturian, Aram 14, 15, 23, 36
Kubick, Stanley 3- 6, 11, 20, 22, 27, 37, 40–42 , 50
 mode of narration 43–45
 style 15, 21, 29-33, 36, 38-39, 44, 45, 47, 49
Kyrie 6

Ligeti, Gyorgi 6, 13, 18, 36, 48, 57n6
lighting 26, 32, 38
light tunnel sequence (aka Star Gate sequence) 19, 35, 46, 48
Lux Aeterna 12, 36

McLaren, Norman 49
Michelangelo's David 44
mise-en-scène 9, 30, 31, 38, 57n4
moonbus 13
Moonwatcher 58n14
monolith 6, 13, 17, 20, 24, 25, 26–27, 40, 58n4
motif 6, 11, 25, 38, 39, 42
musicography 45, 47
 definition 45
 musicographic image 45–50

narrative form 21, 25
Newtonian rules 19
Nichomachus of Gerasa 8
Nietzche, Friedrich 5
nihilism 42

Orion 9, 11, 14, 46, 47
 control console 10

Pan Am space shuttle see Orion
Poole, Frank 14–16, 17, 23, 28–29, 32, 33, 37
process shot 30

radio signal 14, 17
Requiem 6, 13, 18, 36, 48 see also Kyrie
Russian scientists 10–11

science fiction 3, 32, 43, 44
second law of thermodynamics 19, 57n7
Sentinal, The 59n17
set design 38, 39
Smuts, Jan C. 41
solarization 19
sound 30, 36, 38
Star-Child 20, 26-27, 28–29, 34, 41–42
Stravinsky's Le Sacre du Printemps 44
Strauss, Johann Jr. 9
Strauss, Richard 5
super motif 7, 39
Super Panavision 55, 59n16, 70
synchronicity 24, 40
synesthesia 45

Toa Te Ch'ing, The 8
triad 5, 6, 8, 9, 17, 20, 24, 27, 38

Unsworth, Geoffrey 31

voice-over narration 6, 25, 44

Zarathustra see *Also Sprach Zarathustra*

About the Author

Albert Halstead is founder and director of Leonine Productions in Waverly, NY which has been in business since 1974. He graduated from Clarkson College of Technology in 1968 with a Bachelor of Science in Chemistry, Ithaca College in 1997 with a Bachelor of Science in Film Production, and has worked professionally in film production since 1997 in both the northeastern U.S. and Los Angeles.

Halstead has written, directed, and produced three experimental films, a documentary, a dance film, a comedy, and six short dramas. The most recently of these include *My Cocktail with Hollis, My Brother's Keeper*, and *Gothic Nightmare* which received several awards at independent film festivals. He has also lectured extensively on film style, science fiction films, and Stanley Kubrick's work in *2001: A Space Odyssey*.